DAPHNE and DAISY

RACHEL BURKE

DAPHNE and DAISY

PAWTRAITS OF SAUSAGE STYLE

hardie grant books

CONTENTS

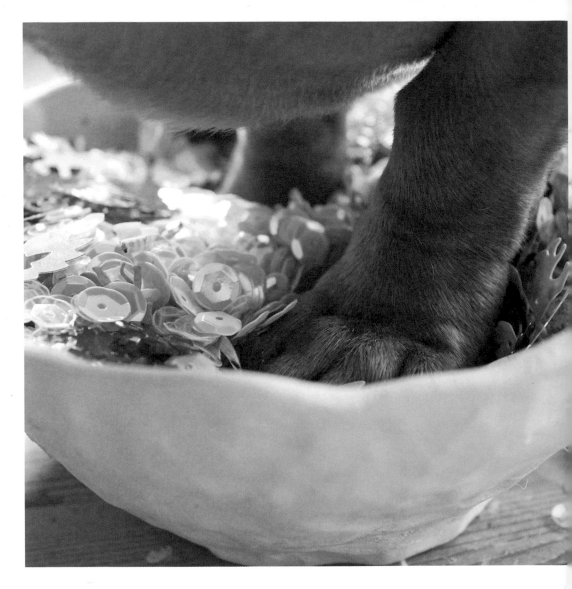

Intro-dog-tion

Daphne and Daisy are the craftiest sausage dog sisters in their neighbourhood – and they're not afraid to bark about it. When they're not napping or snacking, they can be found making colourful wearables and honing a unique brand of style.

Daphne and Daisy have little interest in fitting in with the pack, instead opting to shine bright (like the diamonds they are) in tinsel, gemstones and all that glitters. Commissions for their designs are highly sought after, with waiting lists of three to five dog years.

They believe it is incredibly im-paw-tant to surround themselves with the things they love and to express their personalities through their creations. But while displaying their individuality is paramount, they nonetheless find inspiration in the pages of their favourite magazines (specifically *Dogue*, *Dogmopolitan* and *Barker's Bazaar*).

While Daphne and Daisy share many passions, their personalities are very different. As such, artistic conflicts have been known to arise. While Daisy manages these tensions by hiding under the coffee table, Daphne expresses her opinions more vocally.

They are eager to introduce themselves, and share with you all the things they love most.

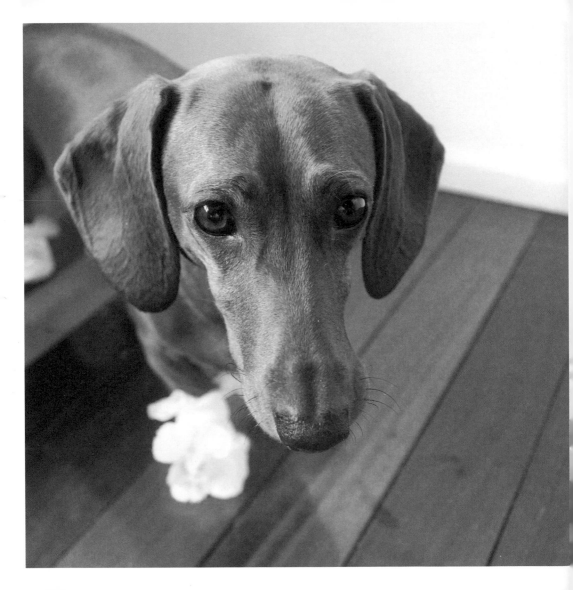

MEET Daphne

Daphne discovered her love for craft and design as a puppy, when she decided to bedazzle a bag of dog food. She was so pleased with the results, she went on to decorate a stick, her favourite ball and the pooper scooper – all with fantastic results.

Daphne is always sure to let her little sister, Daisy, share in the activities, but she is not afraid to sit on Daisy if she doesn't like what she has made.

When Daphne is not glittering things, she enjoys the title of 'Noisiest Neighbourhood Dog', an award she has won three years in a row.

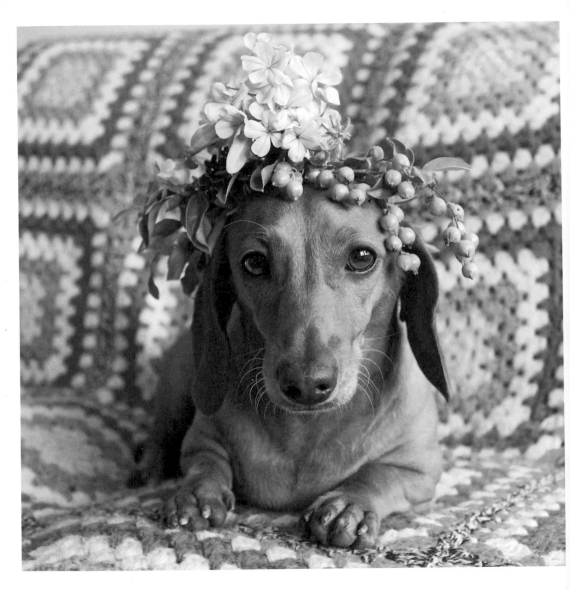

MEET Daisy

Daisy is first and foremost a hat lover. She adores any kind of decorative bonnet that allows her personality to shine through (and they're a wonderful complement to her unique brand of worry-faced cuteness).

Daisy is a little shy and can find it hard to make conversation with new animals, so she uses her wearable creations to do the barking for her.

In addition to hats, Daisy has a great many other favourite things, such as jewelled booties, stickers and paper crowns. She wants to share these things with the world.

When Daisy is not decorating her head, she is undoubtedly napping in her customised pompom bed and politely asking Daphne to stop sitting on her.

chapter 1
FLOWERS

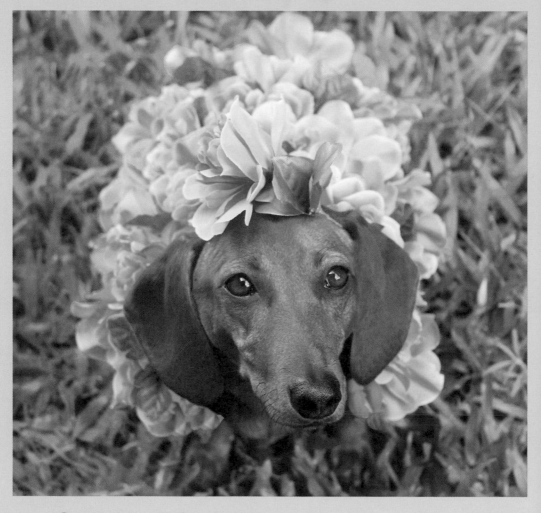

Daphne and Daisy take a lot of their style inspiration from their

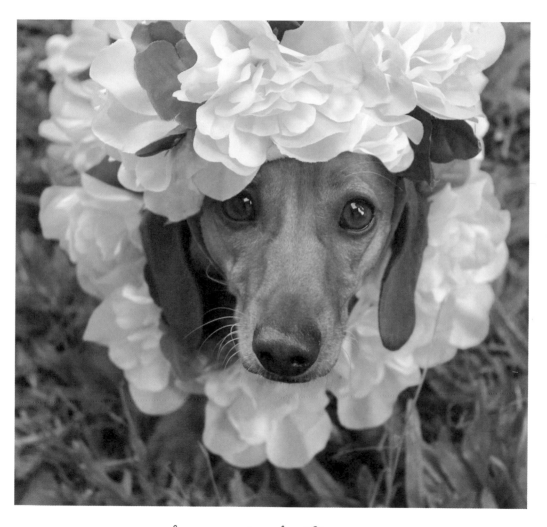

favourite TV series, *Sausage in the City*, starring Carrie Bradpaw.

Daphne's Tip # 74:

iT'S ALWAYS THE RiGHT TiME FOR A FLORAL BONNET.

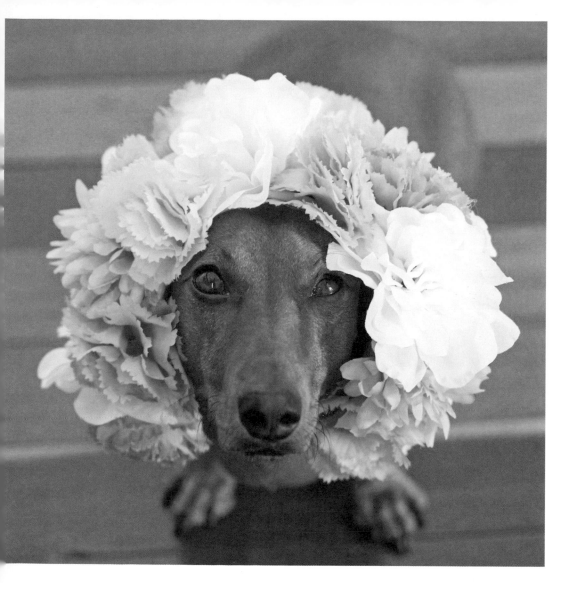

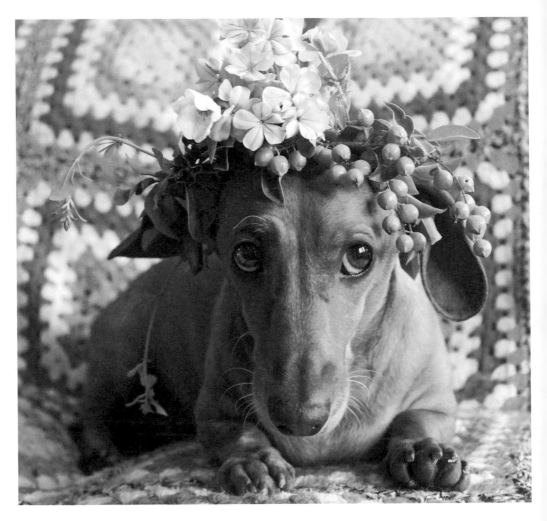

Daisy picked these *blooms* herself ...

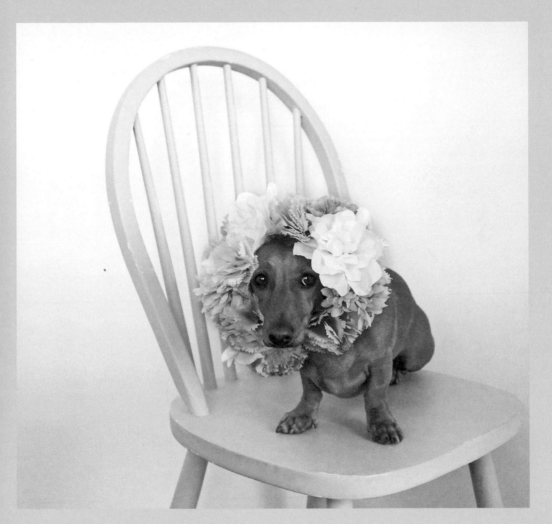

... she takes her *flowers* very seriously.

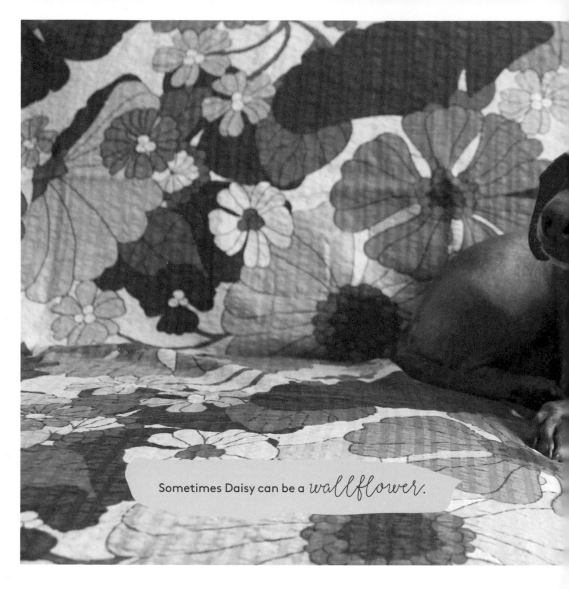

Sometimes Daisy can be a *wallflower*.

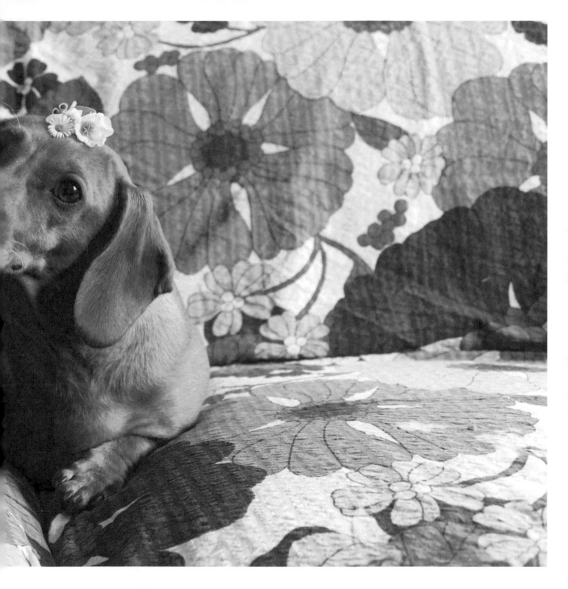

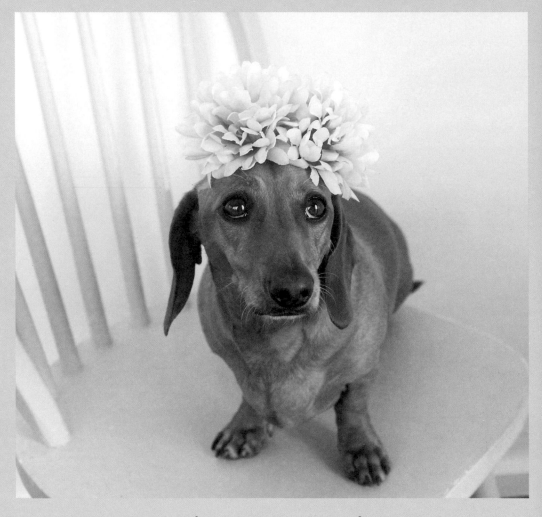

Daisy believes that *fascinators* make you *fascinating*.

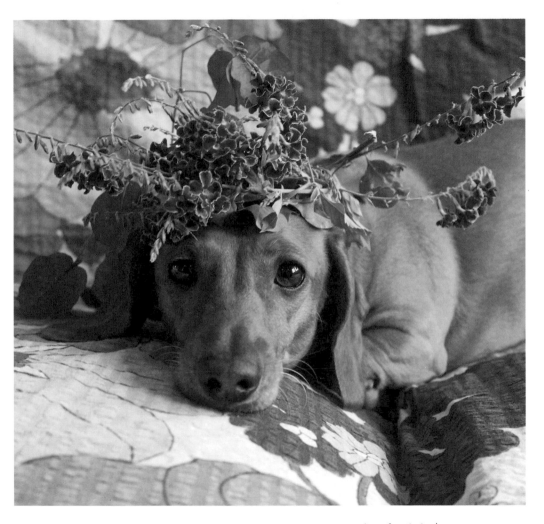

If Daisy is ever feeling blue, she wears *purple bells!*

A whisker of truth from Daphne:

FLORAL BOOTIES ARE AN INVESTMENT PIECE. CUSTOMISE YOUR OWN SO YOU CAN STAND OUT FROM THE PACK.

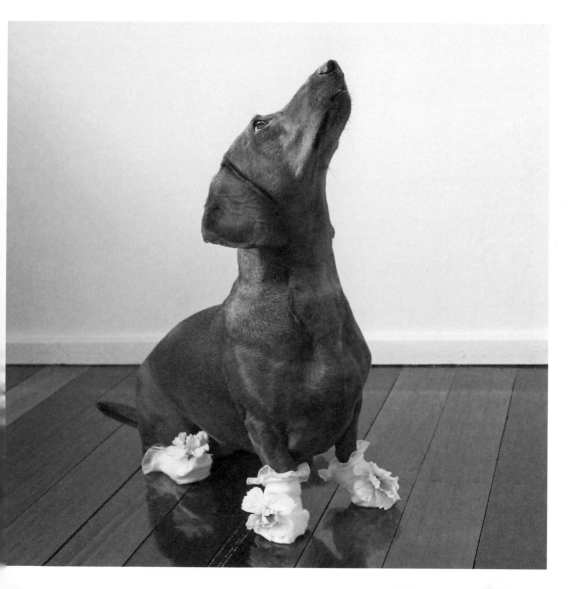

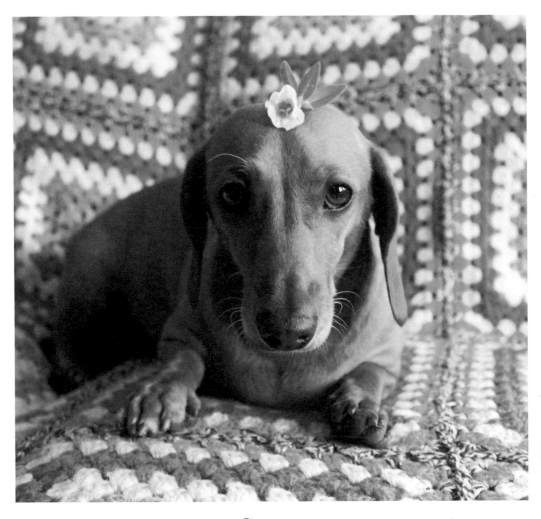

Daisy by name, *Daisy by nature.*

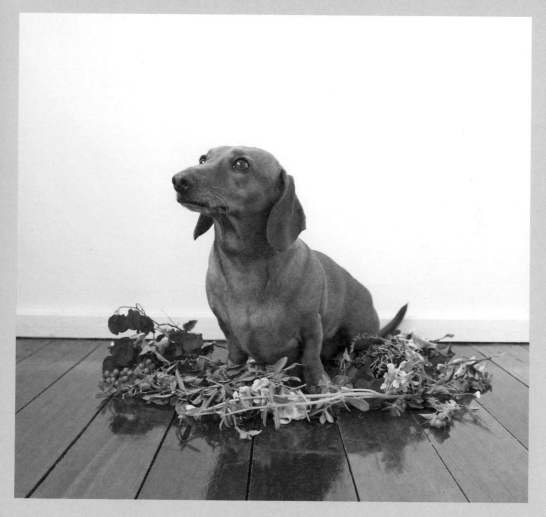

Best of the bunch!

chapter 2
POMPOMS

Daphne's Tip #17:

TEXTURE iS
iM-PAW-TANT.

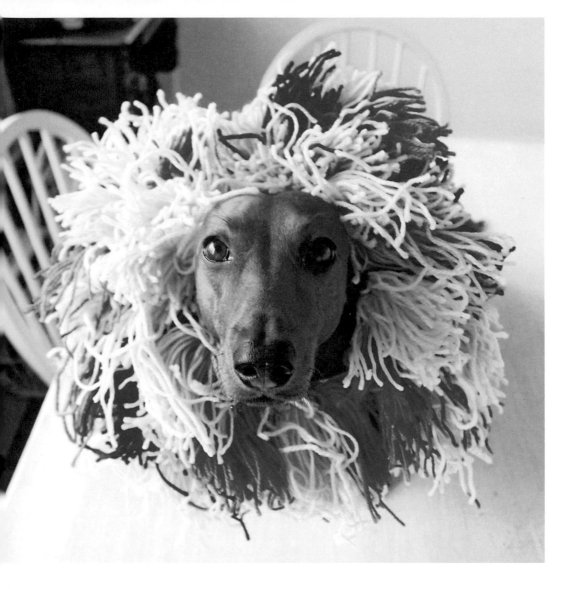

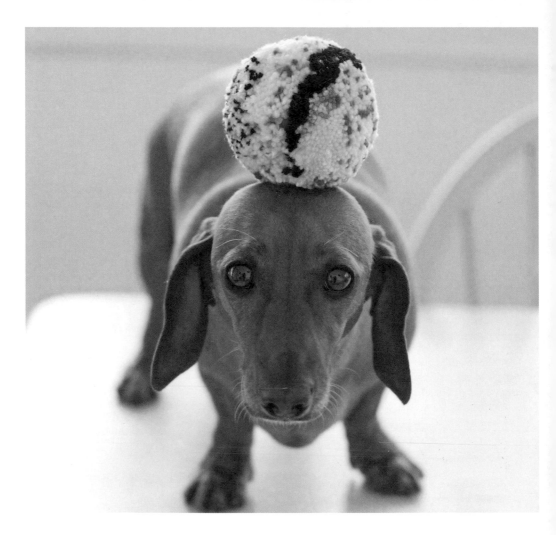

Daisy never makes a *pompom* she can't keep.

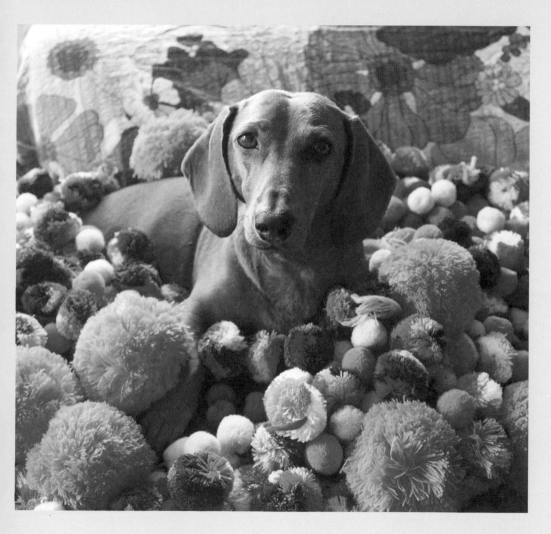

You can never be too *pom-poms.*

Did someone say *lunch?*

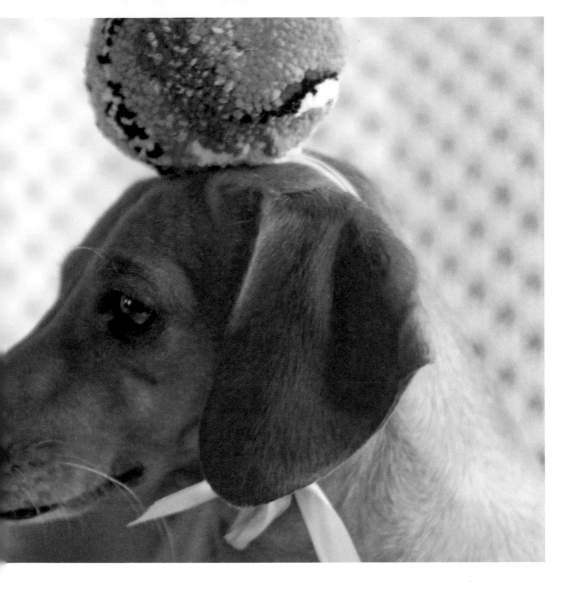

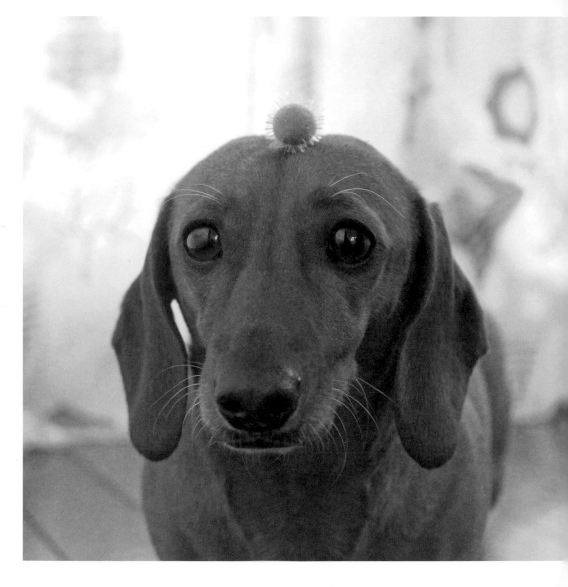

IF SHE RUNS OUT OF PAWS,
DAISY CARRIES HER
craft supplies BACK TO
THE STUDIO ON HER HEAD.

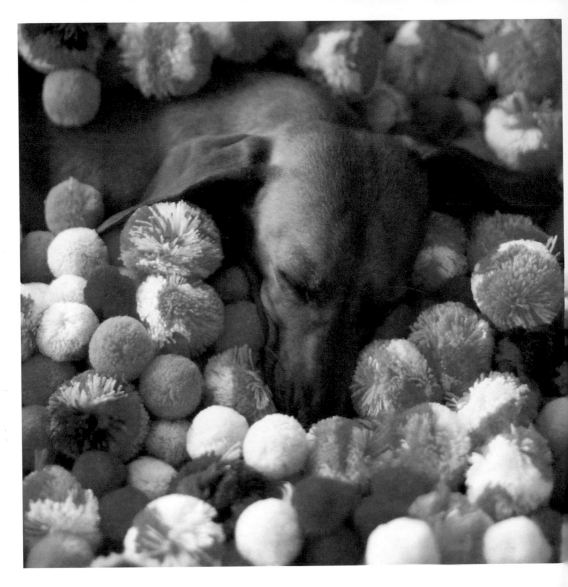

DAISY SLEEPS BEST ON A BED
of pompoms.

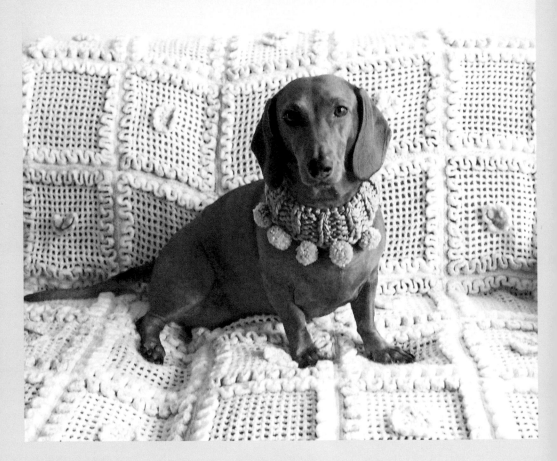

Crafty *queens* ...

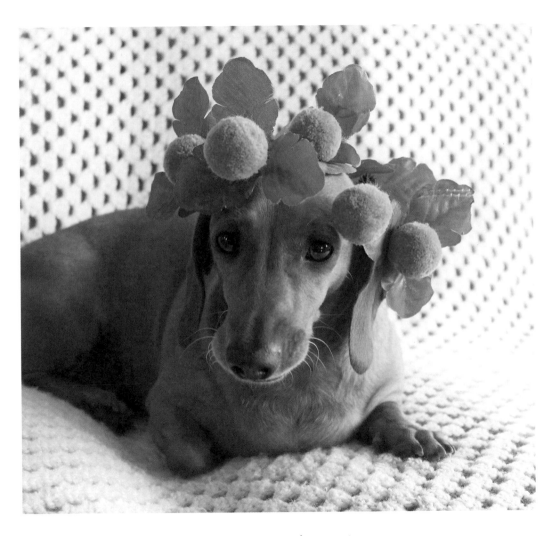

...need crafty *crowns*.

chapter 3
SHINY THINGS

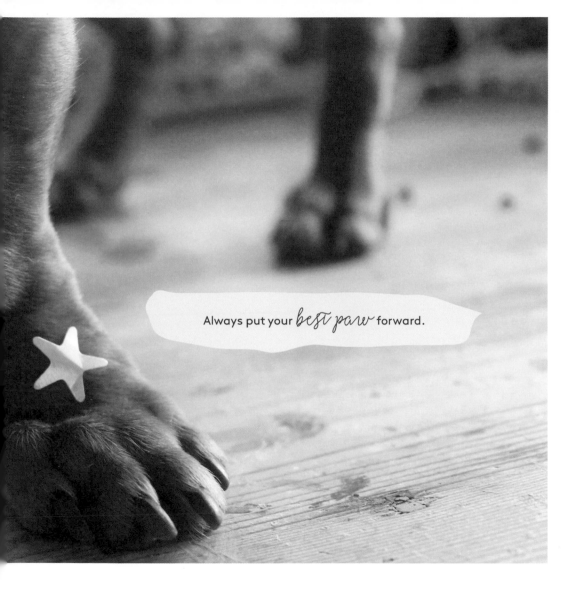

Always put your *best paw* forward.

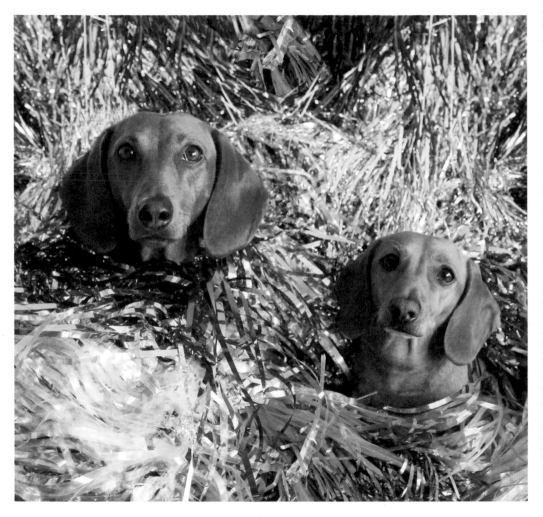

Shine bright *like a diamond.*

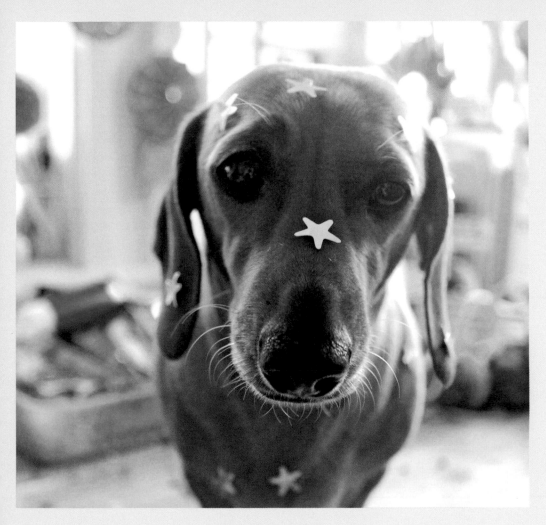

A true *starlet*.

Daphne's Tip # 8:
iF iN DOUBT, WEAR A SPARKLY COAT.

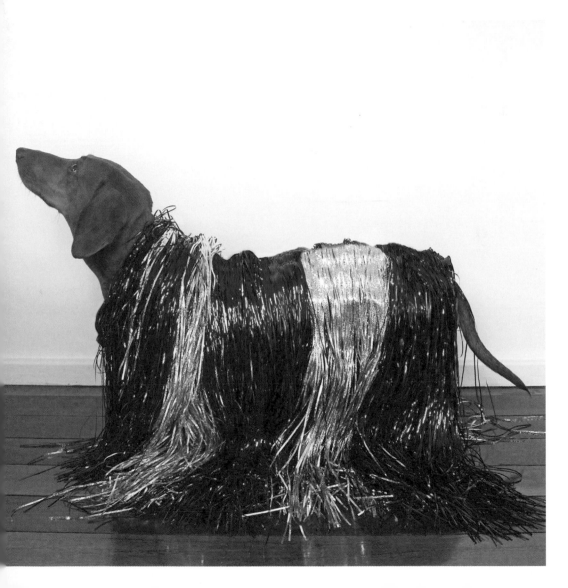

BEFORE YOU LEAVE
THE HOUSE, LOOK
IN THE MIRROR AND
add another accessory.

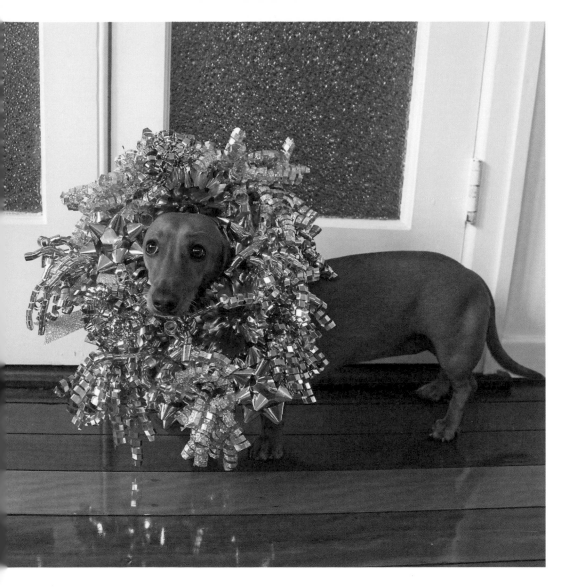

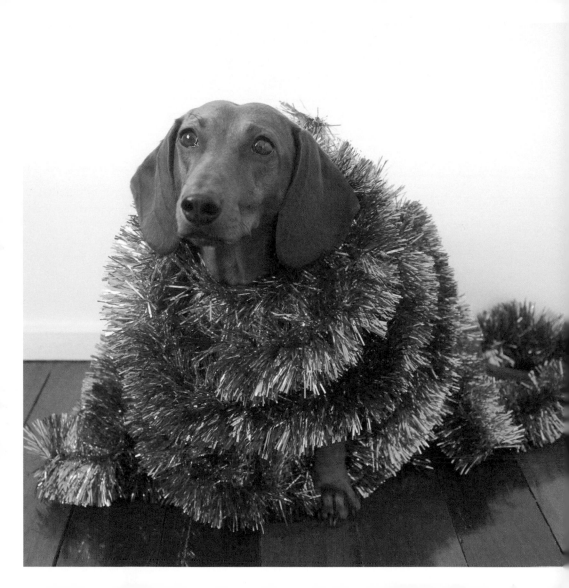

DAPHNE'S TIP #32:

Tinsel is trans-seasonal.

WHY SHOULD YOUR CHRISTMAS TREE HAVE ALL THE FUN?

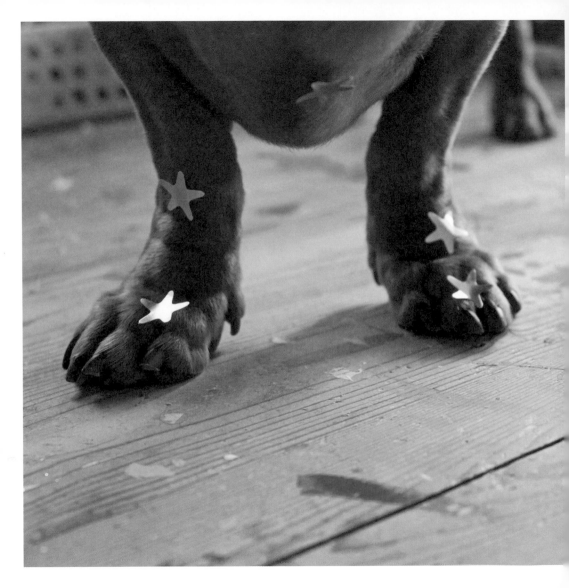

When you stroll among the stars ... THEY CAN GET STUCK TO YOU.

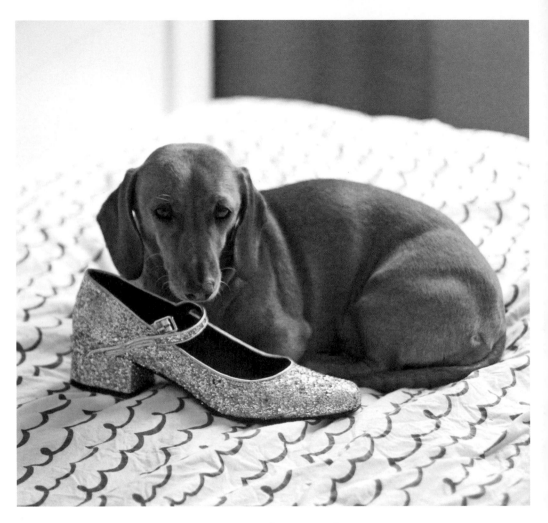

Why have one *glitter shoe* ...

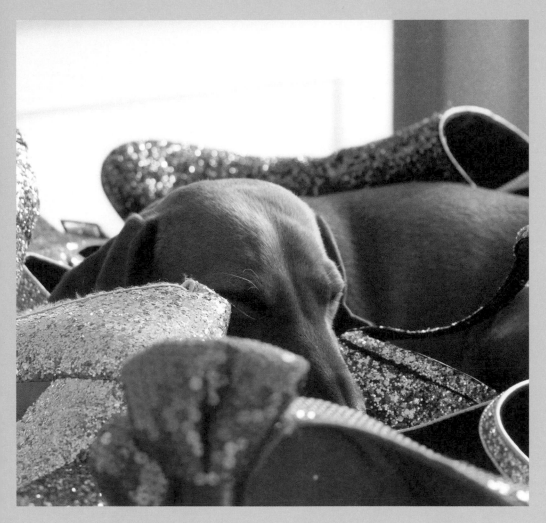

...when you can *have many?*

Daphne's Tip #4:

HOLD ON TO YOUR SPARKLE.

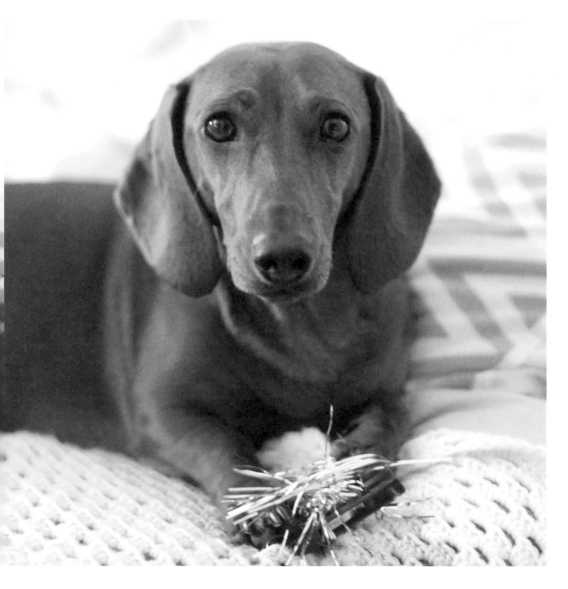

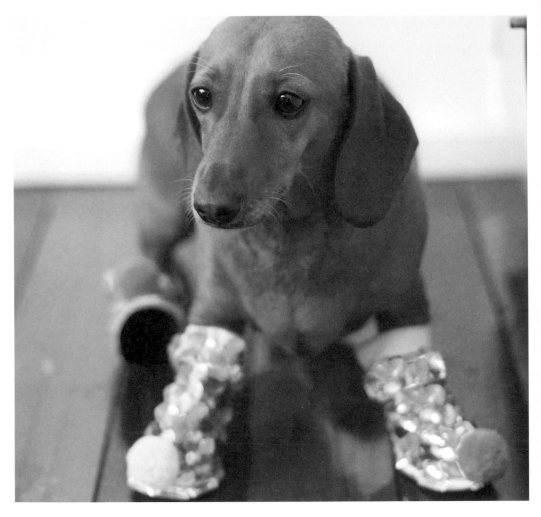

These boots are made for walking.

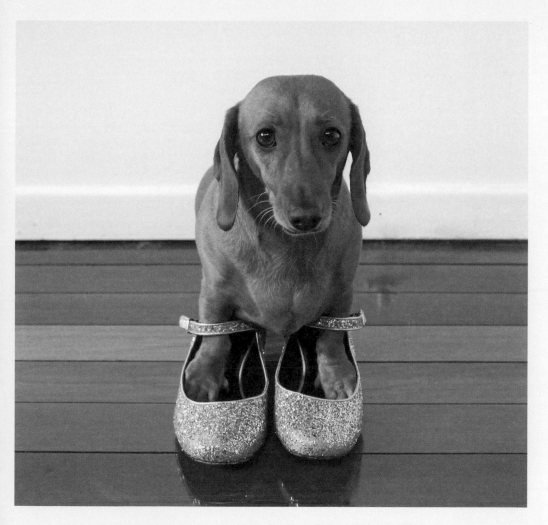

Sometimes Daisy feels like she has *big shoes* to fill.

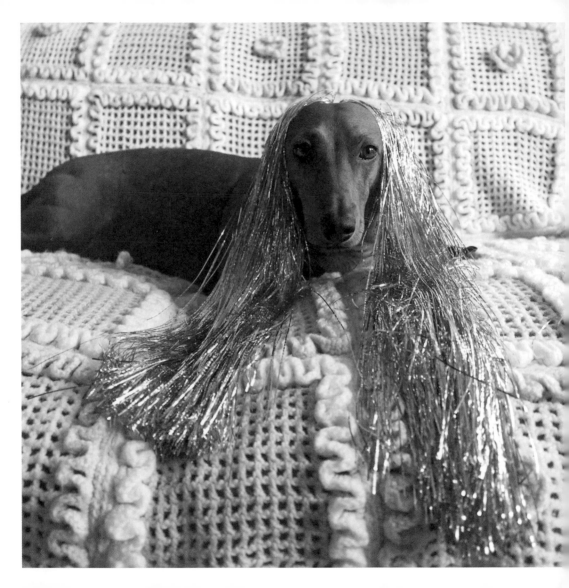

A LOOK STRAIGHT
OUT OF THE PAGES OF
Dogue magazine.

chapter 4
HATS

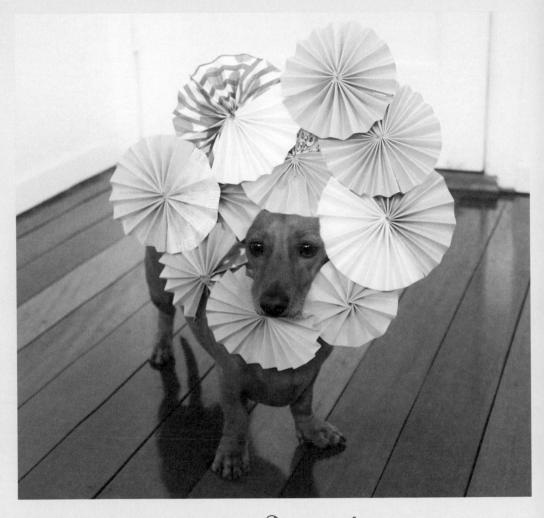

This fancy hat was featured in *Dogmopolitan* magazine.

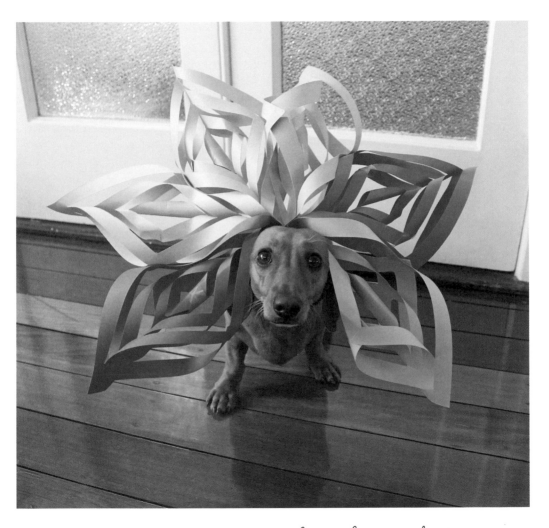

Daisy could chat for hours about her *love of paper hats.*

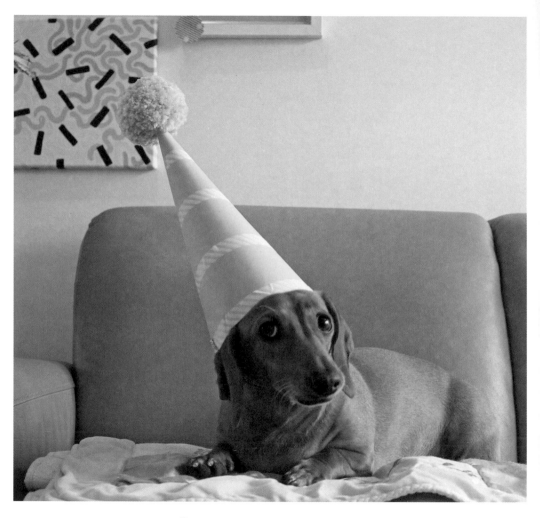

Too much is never enough.

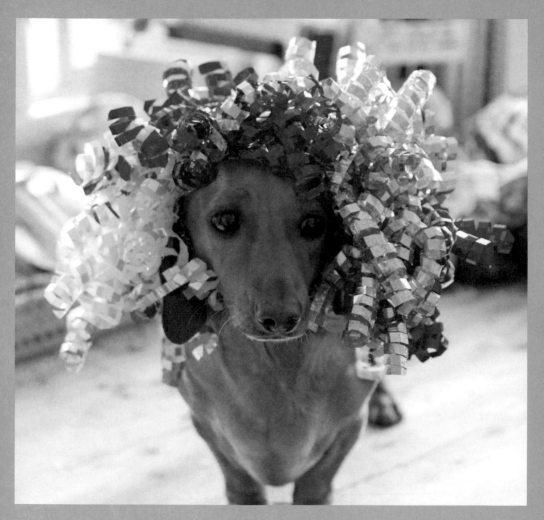

Big hair. Don't care.

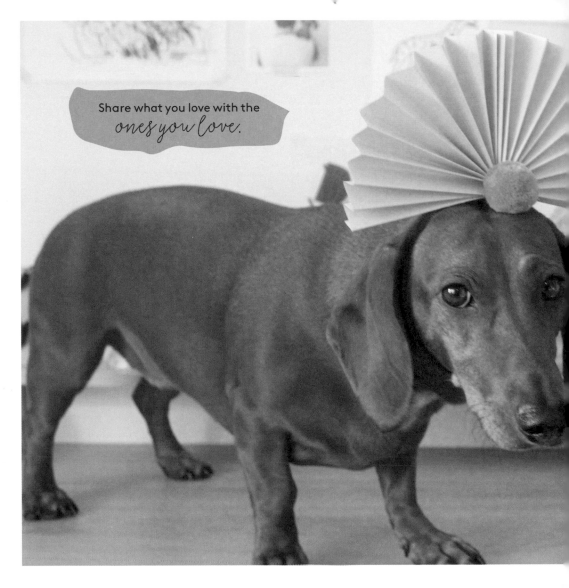

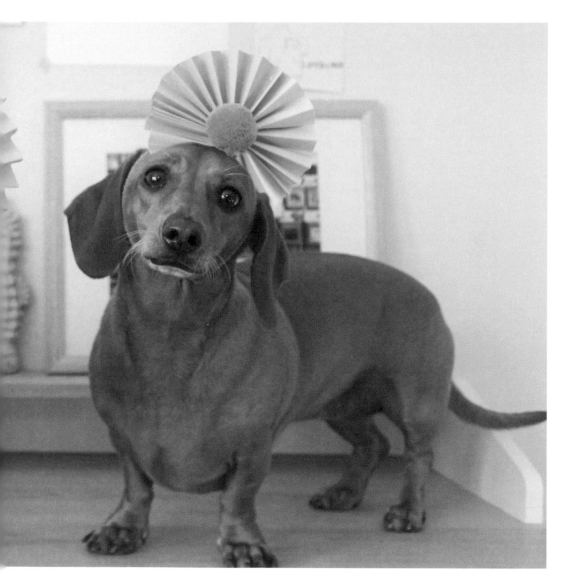

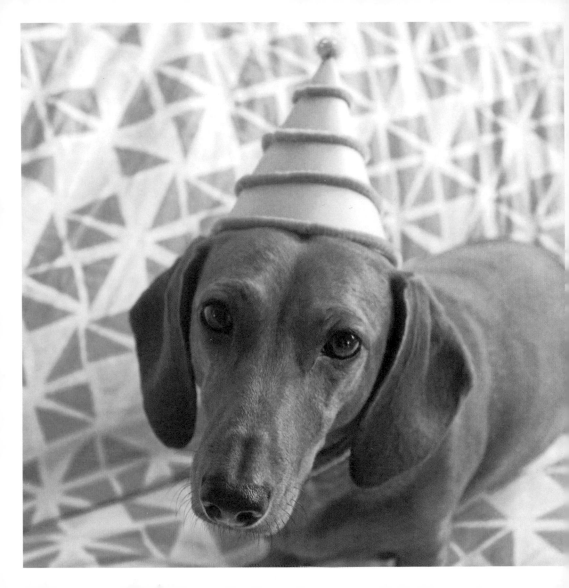

Daphne's Tip #129:
IT'S ALWAYS A PARTY WITH A PETITE PARTY HAT.

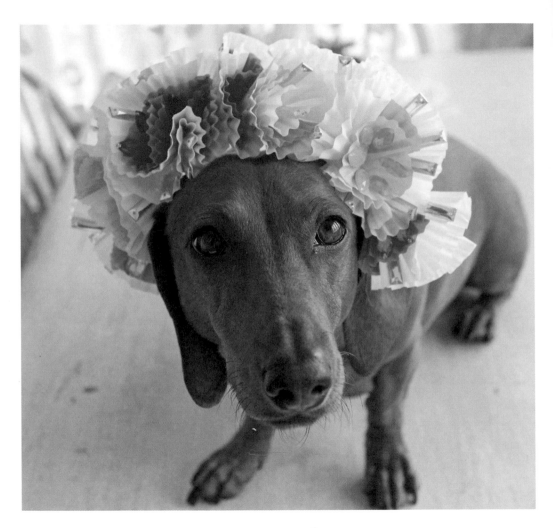

Pawsitively *perfect*.

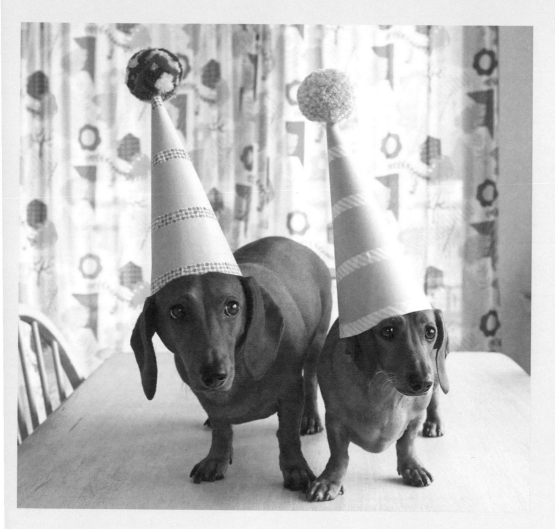

Party pooched.

DON'T EVEN THINK ABOUT BORROWING *one of Daisy's hats* AND NOT RETURNING IT.

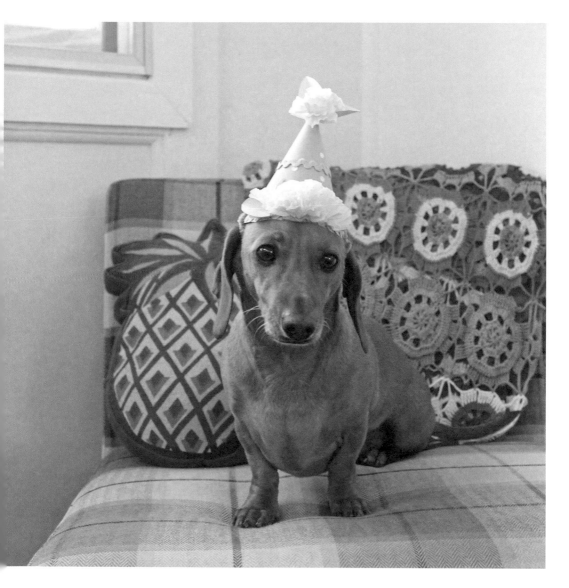

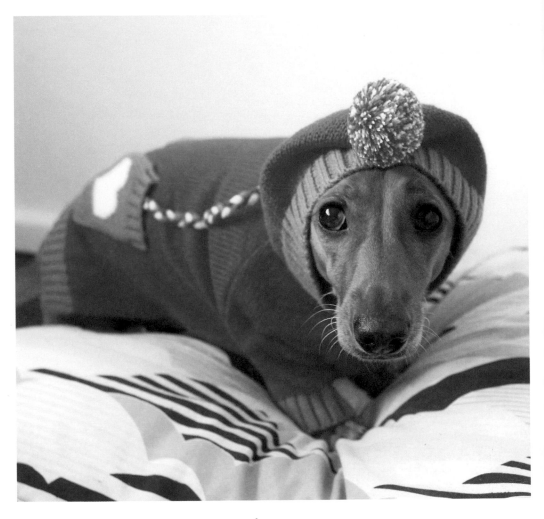

The *perfect* winter look.

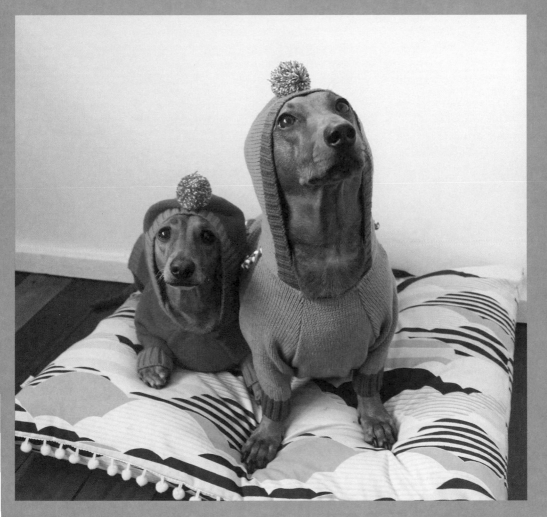

Twinning *is in.*

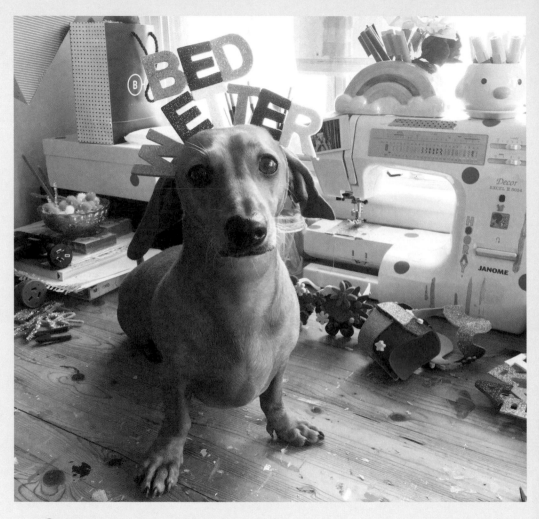

Daisy recommends turning your challenges into a fashion statement.

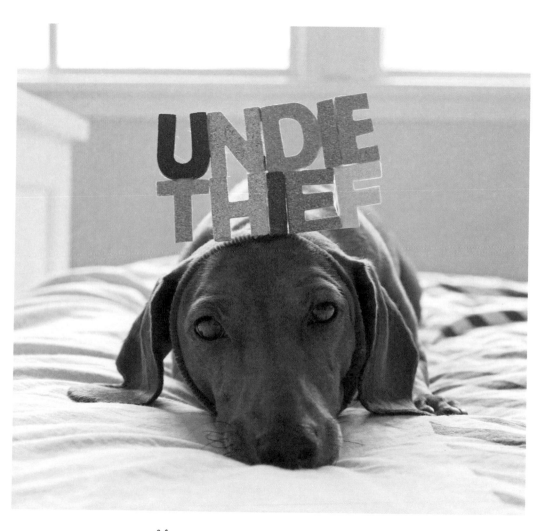

She swears she uses them for her art.

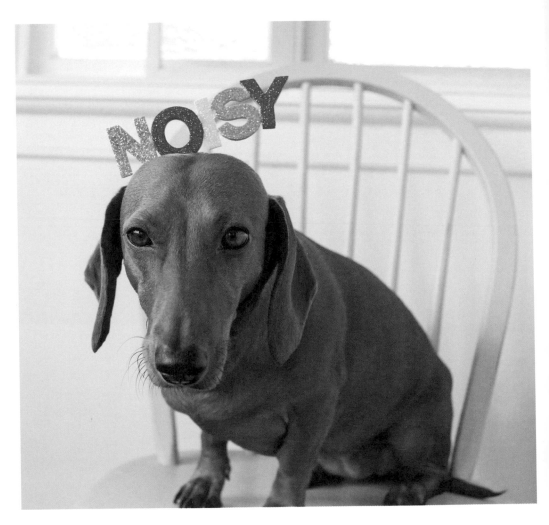

Good style is all about embracing who you are ...

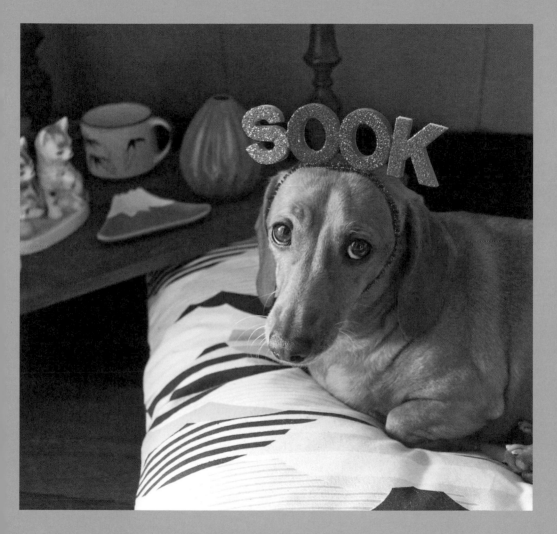

... there is *no use* hiding.

chapter 5
SUNGLASSES

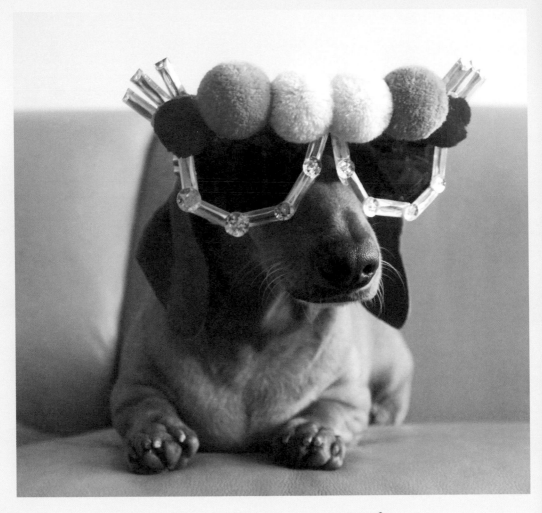

Did someone say *fun-glasses?*

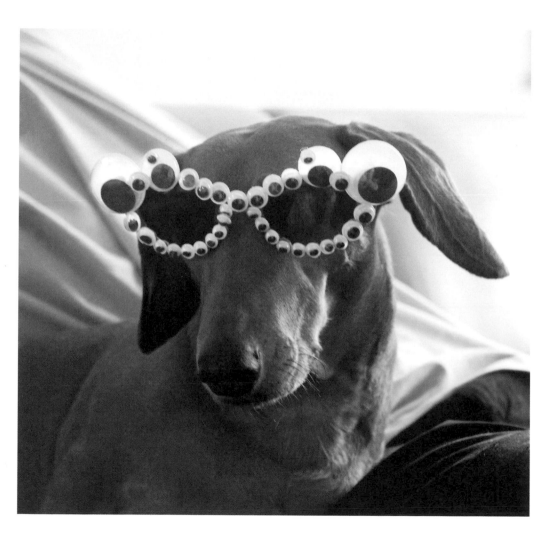

Eyes on the *prize*.

When she can't find the words,
Daisy loves to let her sunglasses do the talking.

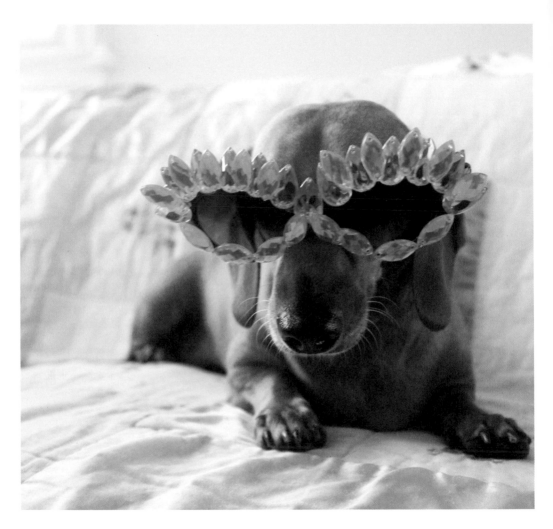

Seeing *green.*

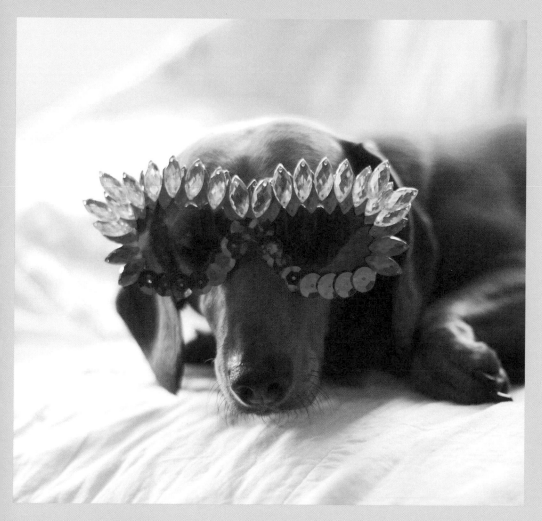

Pretty *in pink*.

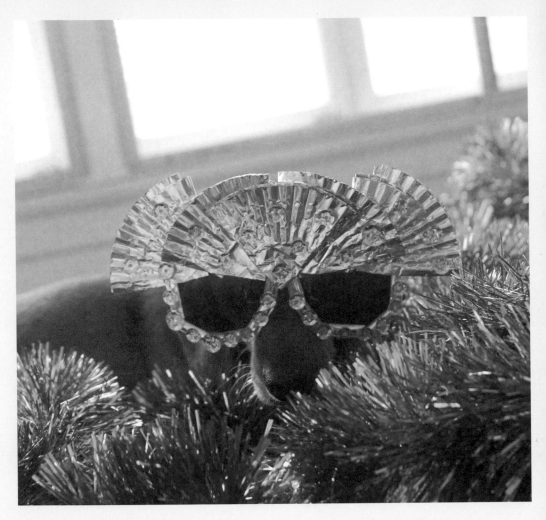

Custom-made metallic frames, as featured in *Barker's Bazaar*.

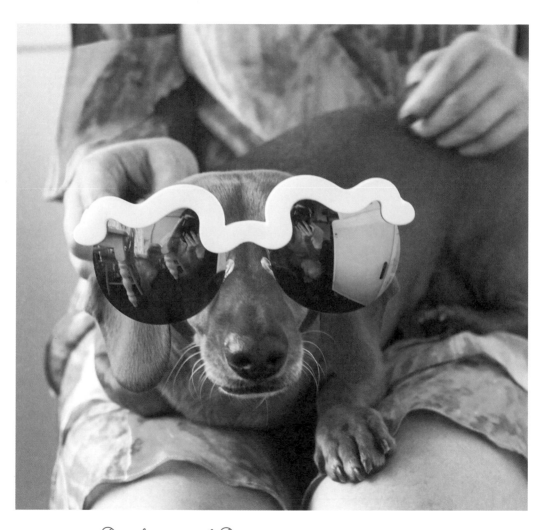

On set, *Daphne and Daisy* are always working their best angles.

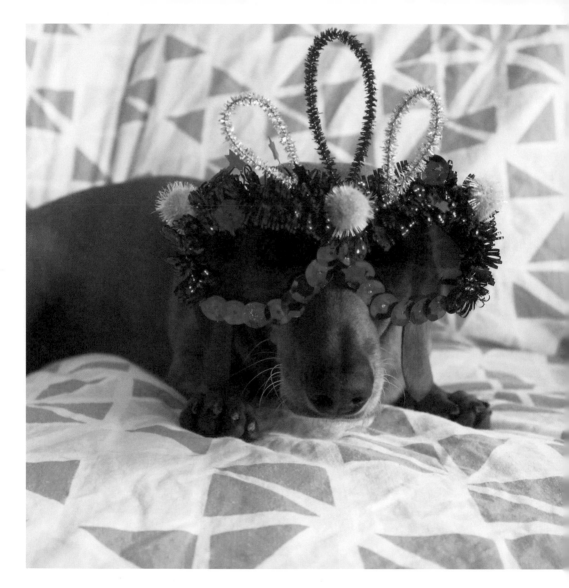

DAPHNE'S TIP #103:

You'd be amazed by

WHAT YOU CAN DO WITH HOT GLUE AND A MEAT CHEW.

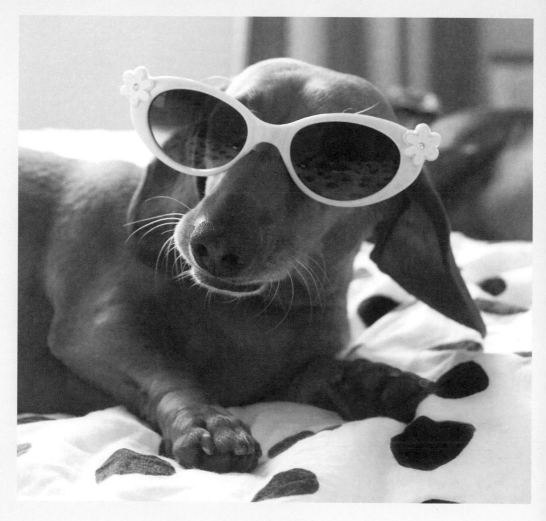

Casual *glamour*.

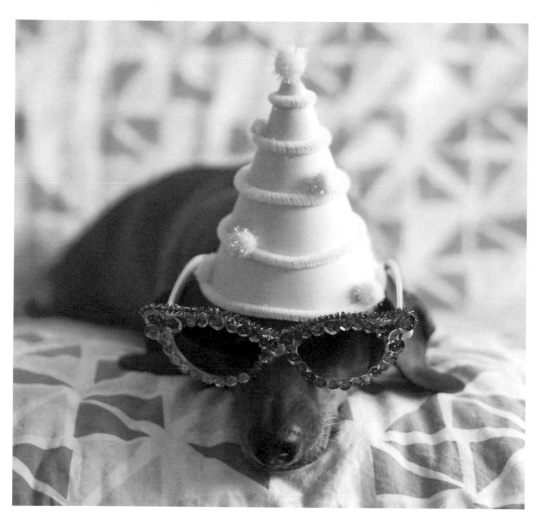

Golden *gal.*

chapter 6
MORE is MORE

Finding your own style is for the *lion hearted!*

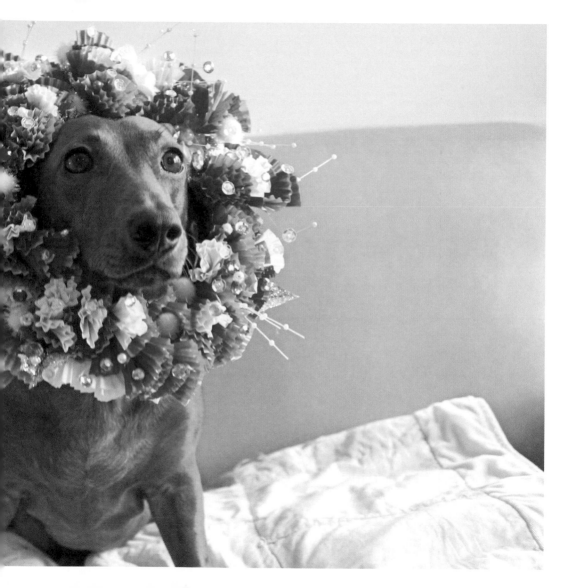

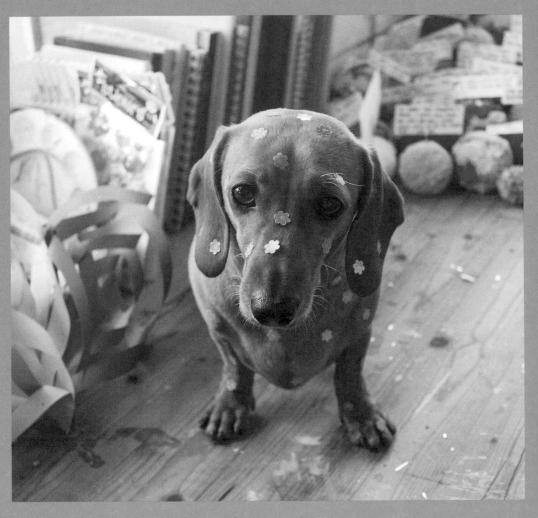

Daisy recommends getting yourself in sticky situations.

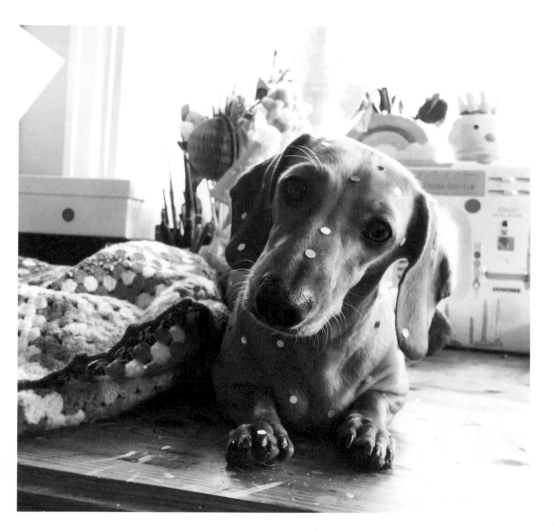

Looking and feeling *dotty*.

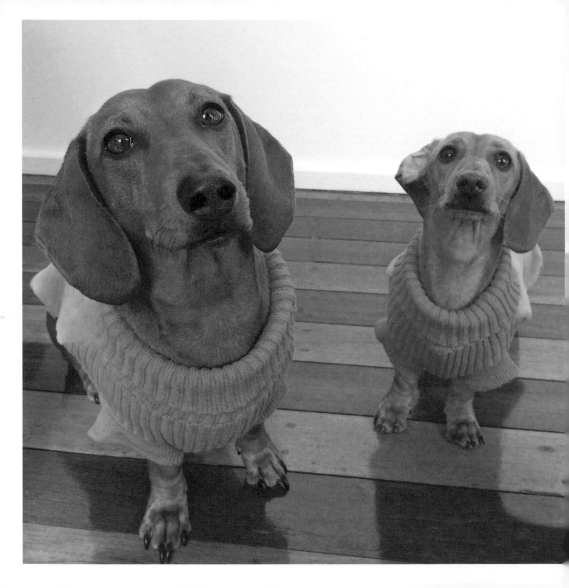

DAPHNE'S TIP #43:
IT'S ALWAYS THE
RIGHT TIME FOR
a cute sweater.

Daphne's *look* is spot on!

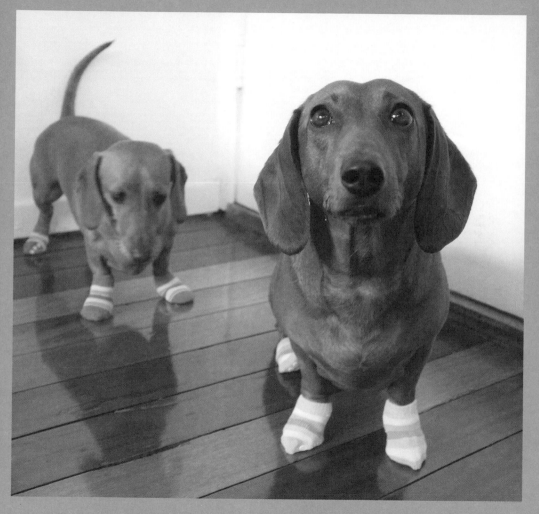

Socks can be a complete outfit.

The perfect look
FOR AROUND
THE HOUSE.

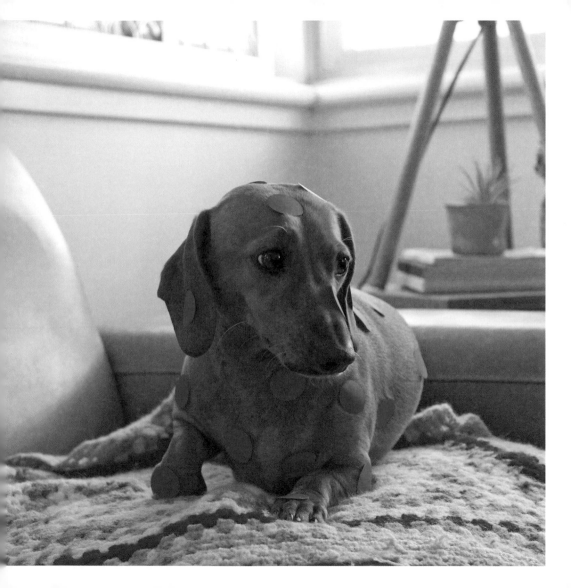

THANK YOU

Thank you to my husband, Thomas, for all your help and strategic snack giving (to Daphne, Daisy and me), and for always being the best, and most tolerant, helper anyone could ever ask for – I love you!

Big thanks to my parents for your unwavering love, support, and puppy-sitting. Thank you to my sister, Laura, who helped bring Daphne into our world back in 2013 – as usual, I probably still owe you for that one!

Finally, sending all the kisses, hugs, pats and 'good guuurls' to Daphne and Daisy, who made this book a possibility and continue to fill our lives with joy and silliness.

ABOUT RACHEL BURKE

Rachel Burke is an Australian fashion designer, photographer and craft artist. As a freelance creative, Rachel has worked for *frankie*, GOMA, The Queensland Ballet, Bonds and Splendour in the Grass.

Rachel continues to document her daily life on her hugely successful blog, i make. you wear it, which follows all her crafty adventures and musings. You can follow more of her sparkly adventures on instagram @imakestagram.

Published in 2017 by Hardie Grant Books,
an imprint of Hardie Grant Publishing

Hardie Grant Books (Melbourne)
Building 1, 658 Church Street
Richmond, Victoria 3121
hardiegrantbooks.com.au

Hardie Grant Books (London)
5th & 6th Floors
52–54 Southwark Street
London SE1 1UN
hardiegrantbooks.co.uk

A Cataloguing-in-Publication entry is available from the
catalogue of the National Library of Australia at www.nla.gov.au

Daphne and Daisy
ISBN 978 1 74379 316 9

Publishing Director: Fran Berry
Managing Editor: Marg Bowman
Editor: Loran McDougall
Design Manager: Mark Campbell
Designer: Sinéad Murphy
Production Manager: Todd Rechner
Production Coordinator: Rebecca Bryson

Colour reproduction by Splitting Image Colour Studio
Printed in China by 1010 Printing International Limited

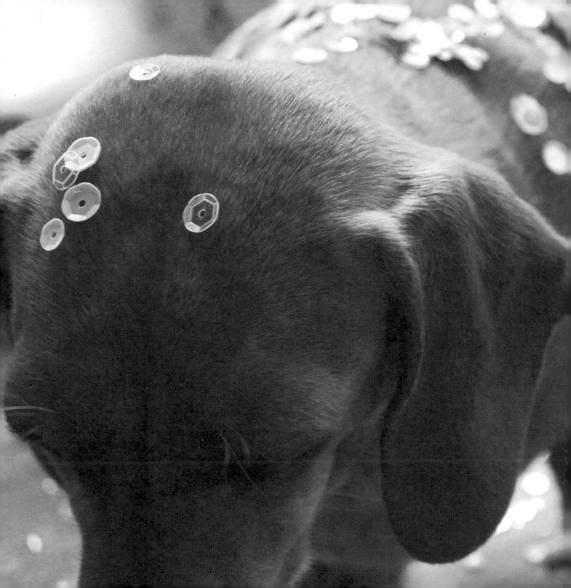